COSMIC
VISIONS

Awakening to remember

Mirtala

Acknowledgments

My sincere thanks to computer experts Tonya Sohm and others
who helped produce these images

and to NASA for the miracle of space photographs
directly connecting us to Cosmos

Sculptures and Words by Mirtala
Space photographs by NASA
Images design by Mirtala

Cover design and book layout by Mirtala

To order additional copies of this book, contact:
Xlibris
844-714-8691
www.Xlibris.com
Orders@Xlibris.com

ISBN: Softcover 978-1-4134-5091-0
 EBook 978-1-6698-6048-8

Print information available on the last page

Rev. date: 12/21/2022

Awakening to remember...

VISIONS
OF HEAVEN AND EARTH

Mirtala

Visionaries have always been individuals who seem able to step out of the river of life and, as their mortal feet are drying, gaze back into the muddy waters and see both the river's source and the infinite sea into which it empties.

They are endowed with the curiosity and capacity to look not at but through. Not content to accept appearance, they penetrate the seductive world to cross over the threshold of the world of ideas and the spirit. For only there, in the intangible world within, can that truth for which they seek be found.

That a visionary artist such as Mirtala should try to make this interior world manifest in the very solidly material form of bronze sculpture is paradoxical, but no more paradoxical than life itself.

If visionaries are natural philosophers, then Mirtala is surely one. The nature of being is her realm of inquiry, the object of her investigation and the subject of her art.

Paul Nagano

1

THE SOURCE

The circle —
oneness, completion, perfection of Creation.

It is dual in nature -
active and passive, spiritual and material.

These complementary polarities
interact in an eternal dynamic rhythm,
each containing elements of its opposite.

And we partake of both…

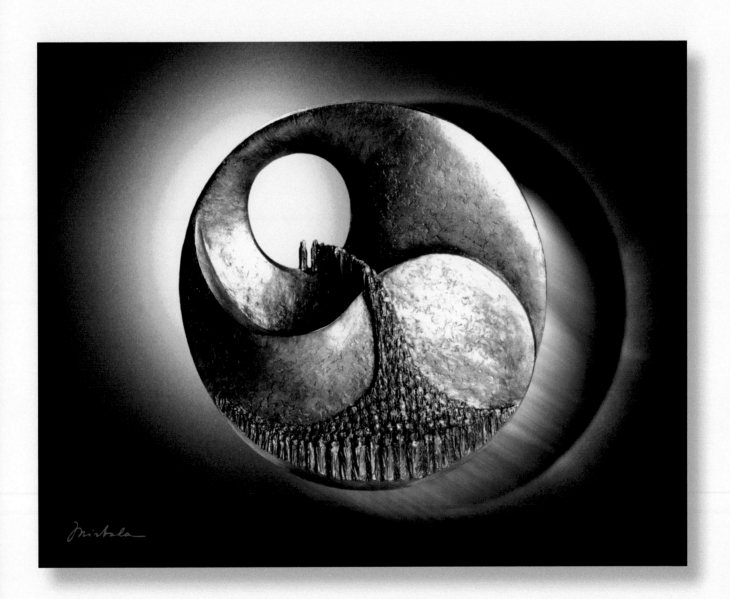

2

PROJECTION INTO BEING

The creative impulse...

From the unmanifest into the world of matter.

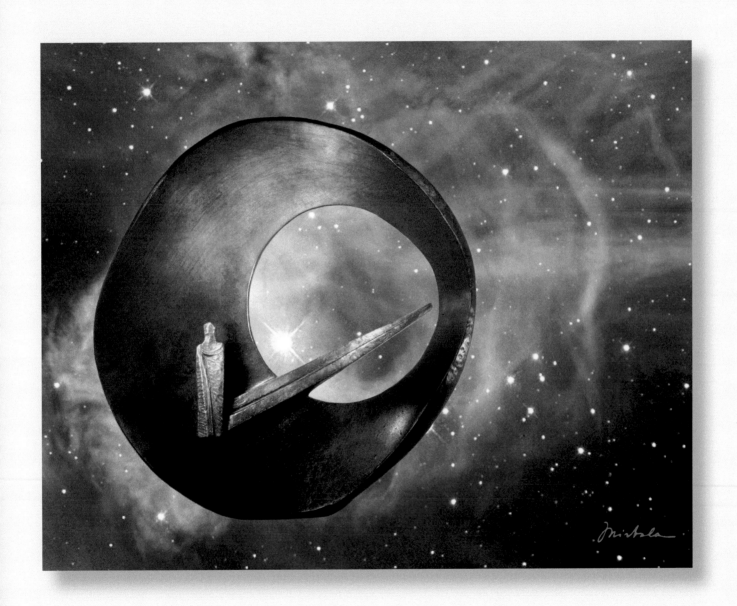

3

ENDLESS BECOMING

From Earth to Heaven –
from the physical into the spiritual.

A continuous progression…

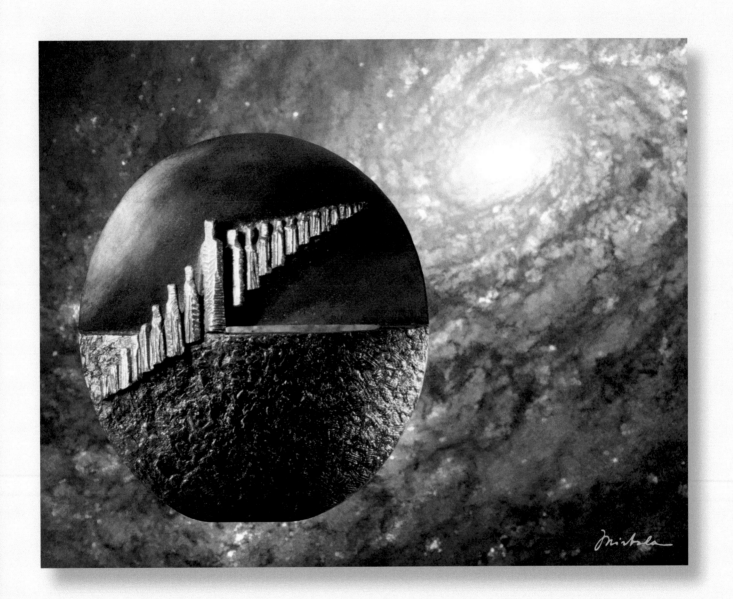

4

INTO MANIFESTATION

Mandorla –

plane of existence,
where matter and spirit are joined.

Created by the intersection of circles –
Earth and Heaven.

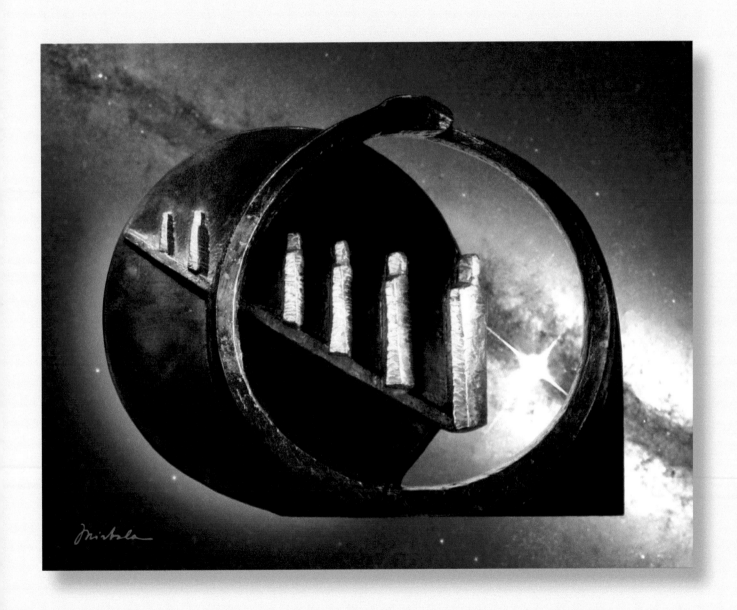

13

5

COSMIC ORBITS

Endless journey through cycles of evolution,

birth and death...

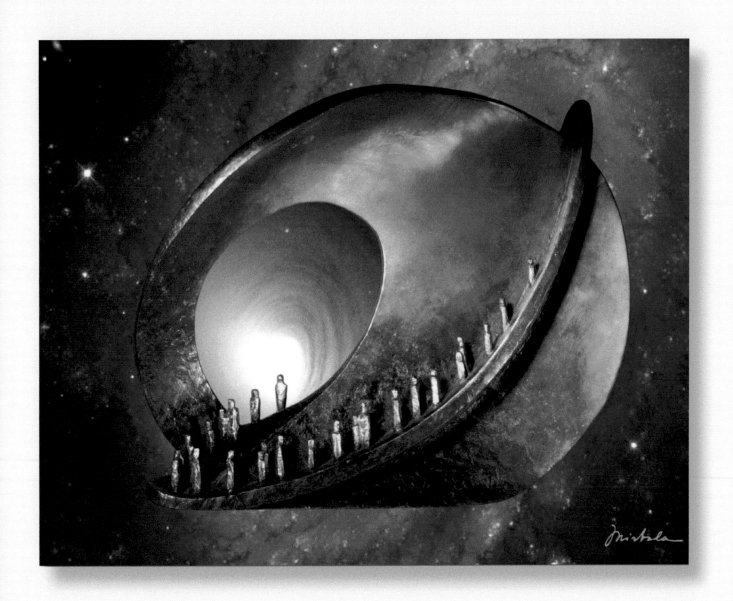

6

MOTHER NATURE

The dual flow
of positive-negative, constructive-destructive forces

converges into what becomes

Manifest Creation or Mother Nature.

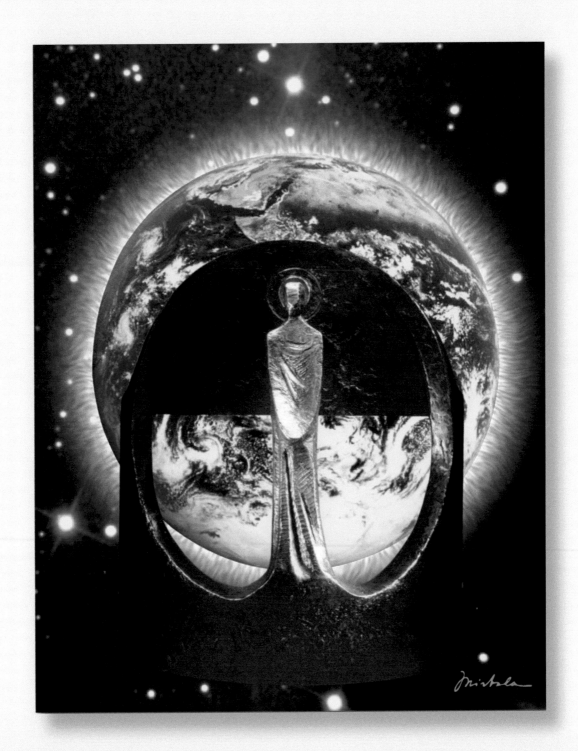

7

LOTUS

Spiritual growth, like the lotus,
starts in darkness,

until it reaches the sun...

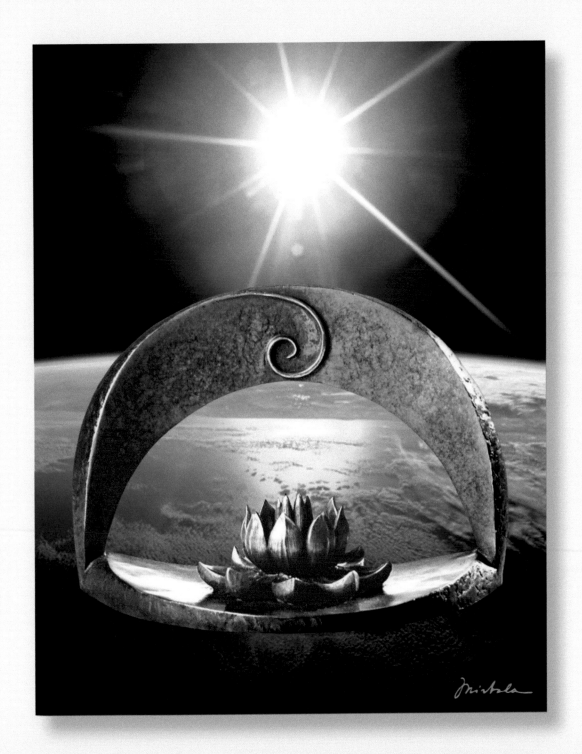

8

CENTRAL SUN

The human being
Caught between the polarities of matter and spirit.

Ever drawn to the Source…

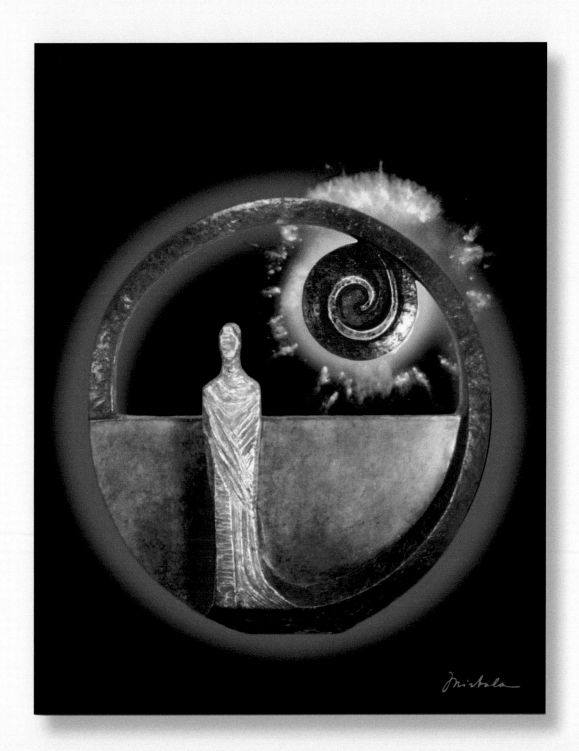

9

THE ENCOUNTER

Meeting one's Higher Self...

By crossing the boundary between the two realities.

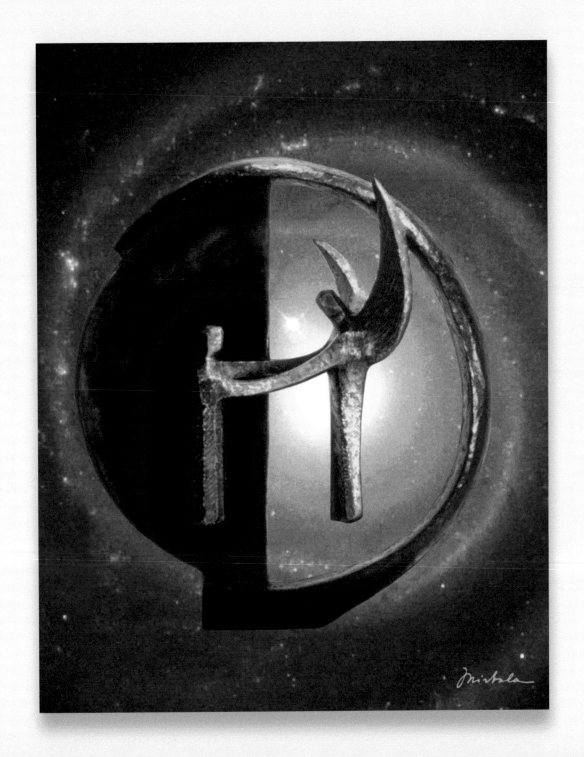

10

PATH TO SELF

The spiral –

cosmic life energy, motion, evolution,
progression from multiplicity to oneness.

Its center – the gateway
from the material into the beyond.

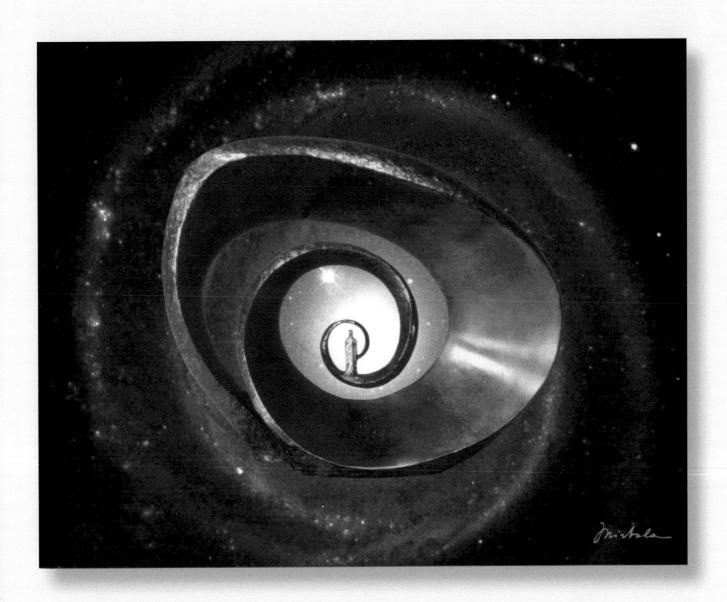

11

EVOLUTION

From an undifferentiated to an individuated state

and spiritual being.

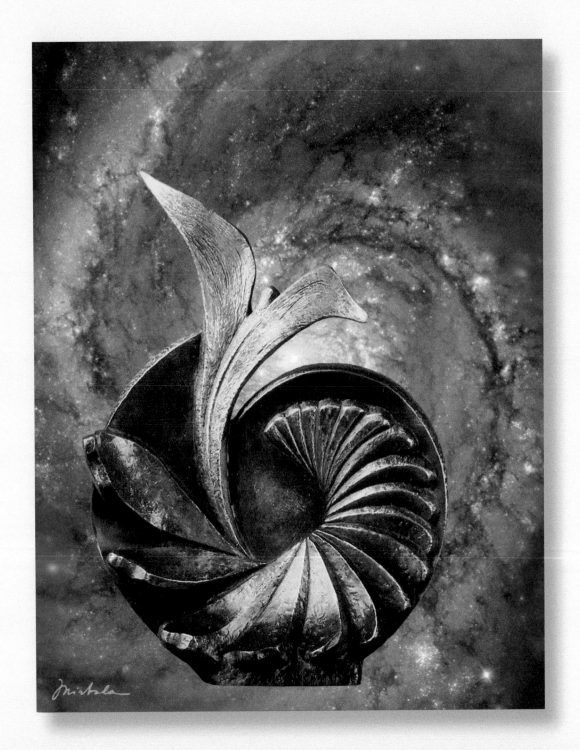

12

INDIVIDUATION

Spiritual freedom lies in non-attachment...

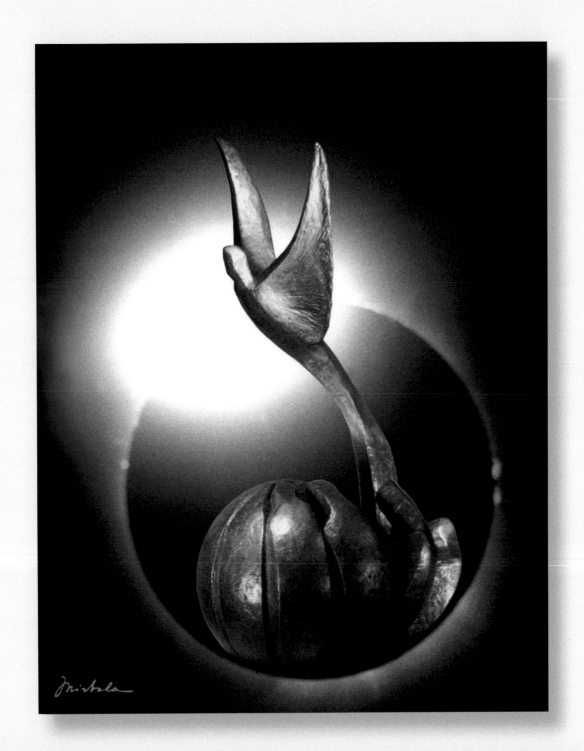

13

ASPIRATION

The inescapable pull towards the Source...

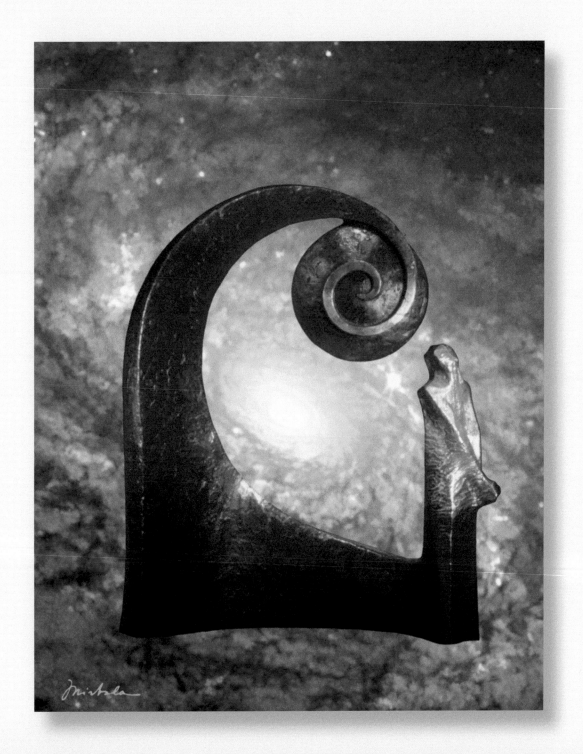

14

TWO OFFERINGS

Two attitudes:

"Give me!"
and
"Thy will be done".

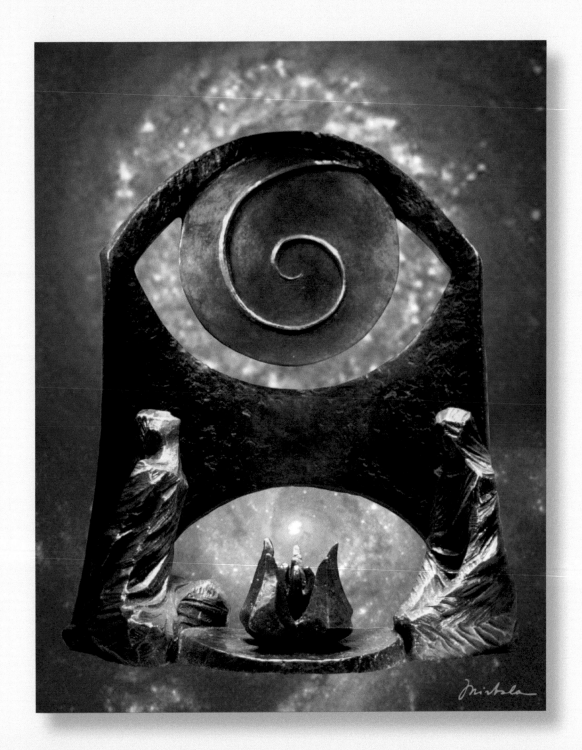

15

PHOENIX

Rising from its ashes...

Immortality and resurrection.

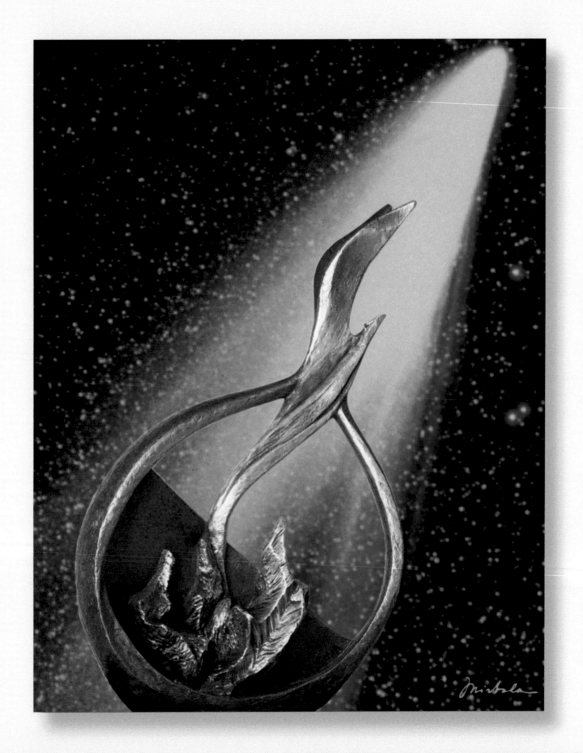

16

DUALITY OF BEING

Existing between two polarities –

good and evil,
creation and destruction,
action and passivity…

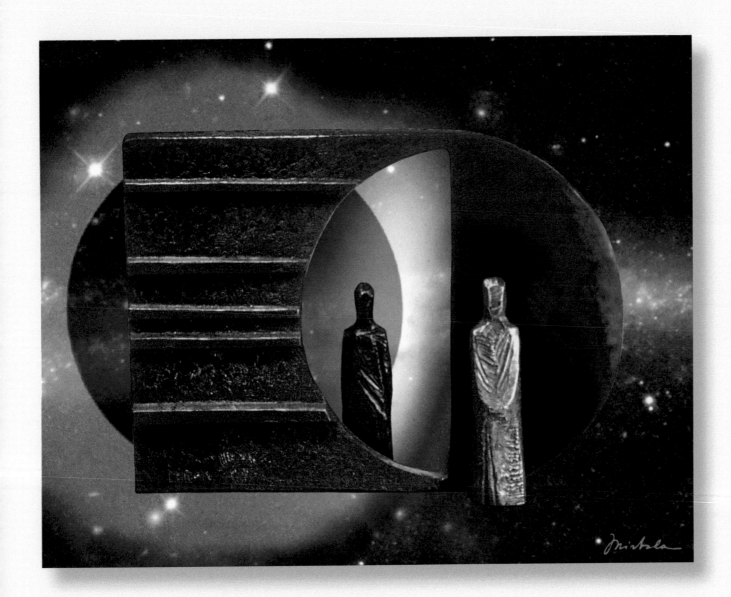

17

WHENCE AND WHITHER

From a potential state – into a state of matter.

From Heaven (circle)
into Earth (square).

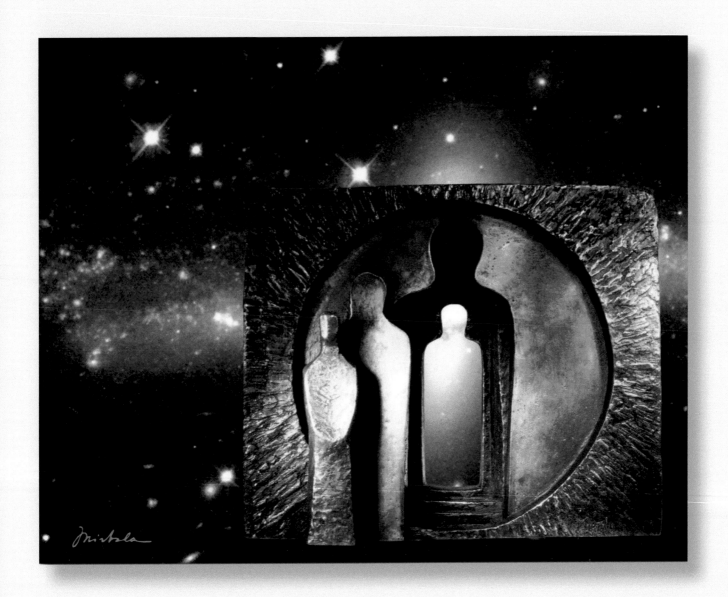

18

THE GUIDES

On our journey into the material plane

we are never alone...

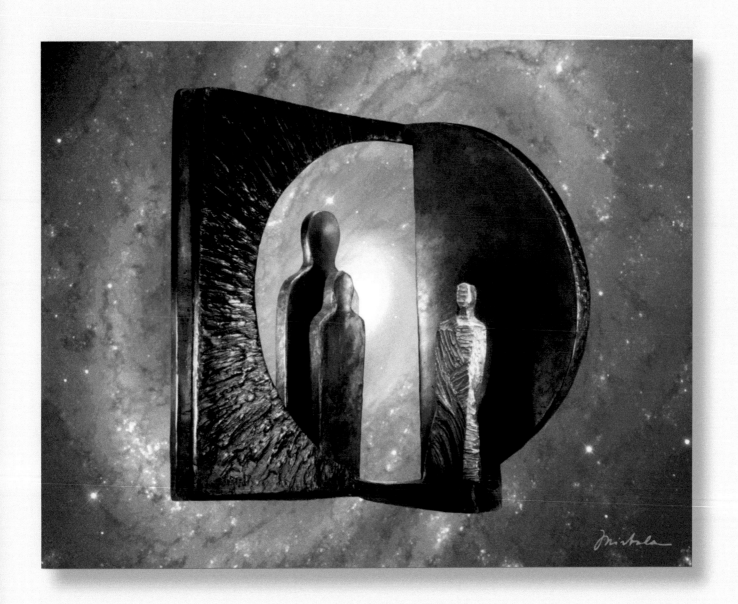

19

FATE AND FREE WILL

The wheels of cause and effect
hold us prisoner,

until we become free and step out.

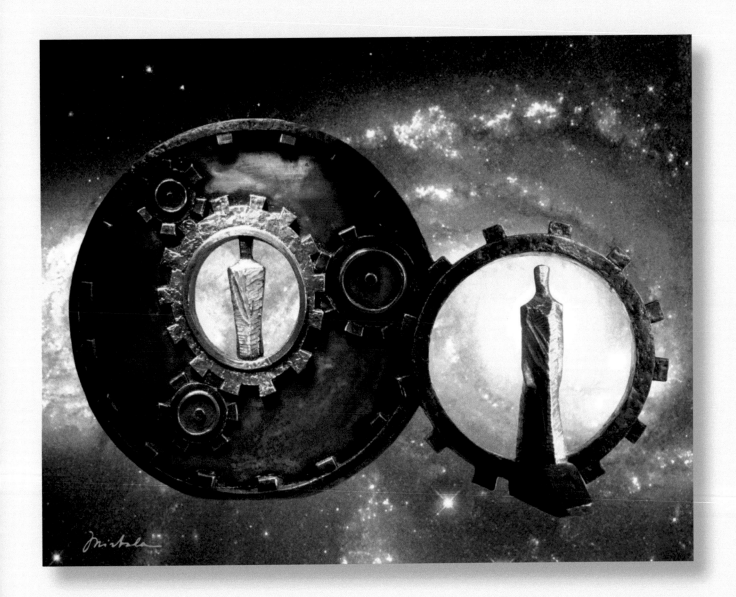

20

WHEELS OF COINCIDENCE

Our true Self

reaches out across the material barrier…

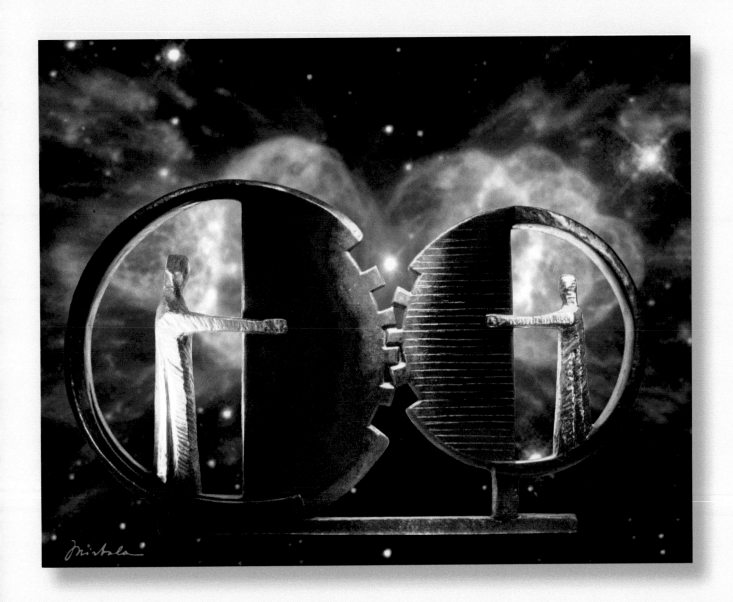

21

INTERDEPENDENCE

No one is an island...

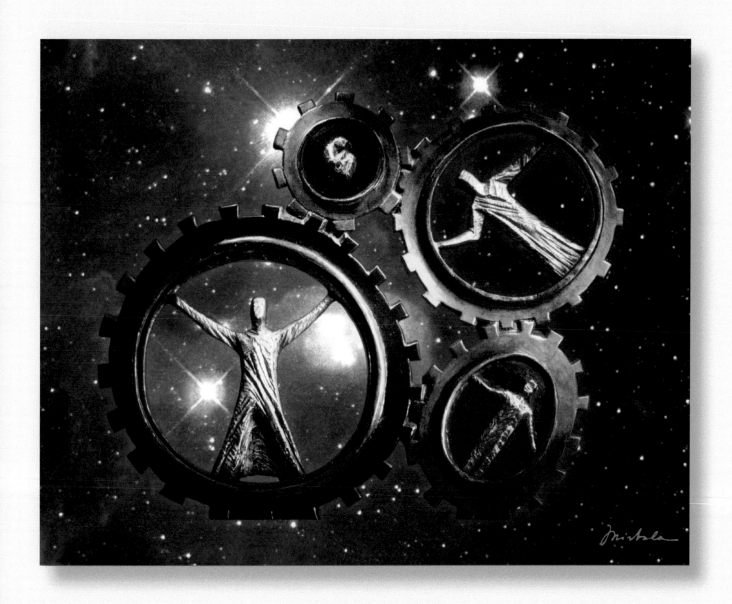

22

LIBERATION

Emergence into magnificence…

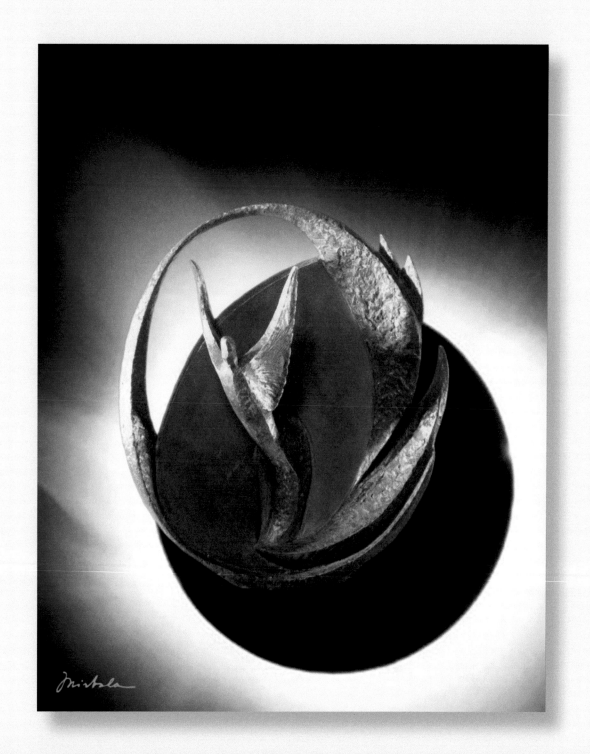

CONTENTS

Printed in the United States
by Baker & Taylor Publisher Services